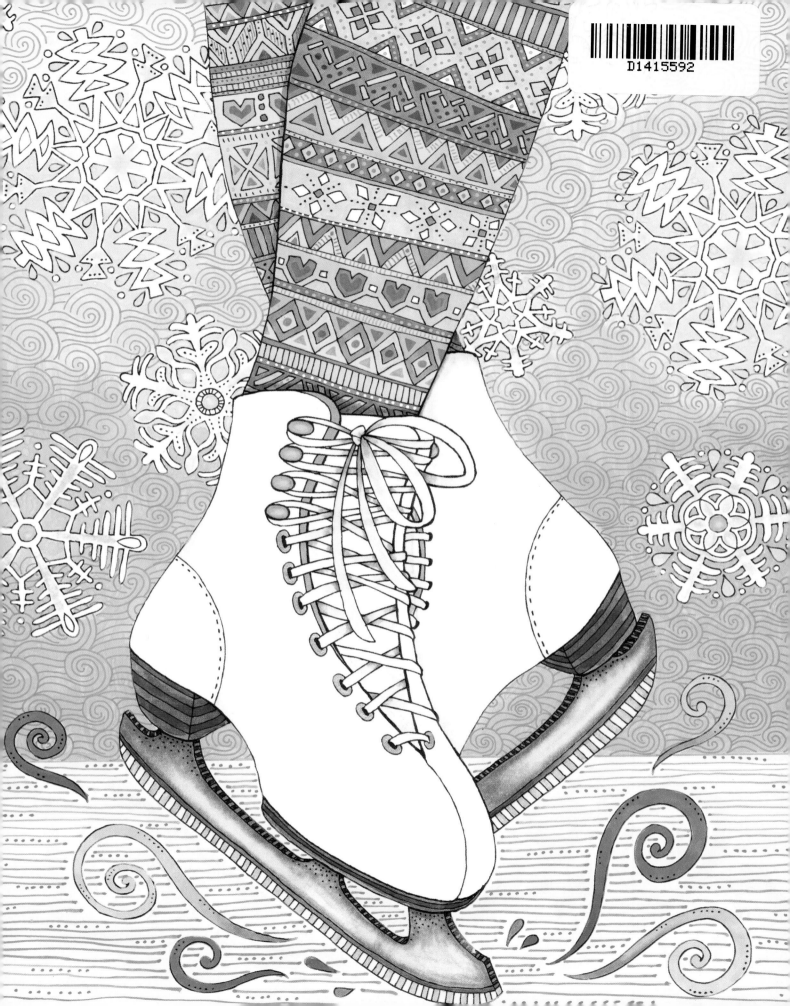

What's My Style?

I love creating elaborate patterns packed with detail so I can do lots of intricate coloring. I try to use as many colors as possible. Then, I layer on lots of fun details. Here are some more examples of my work.

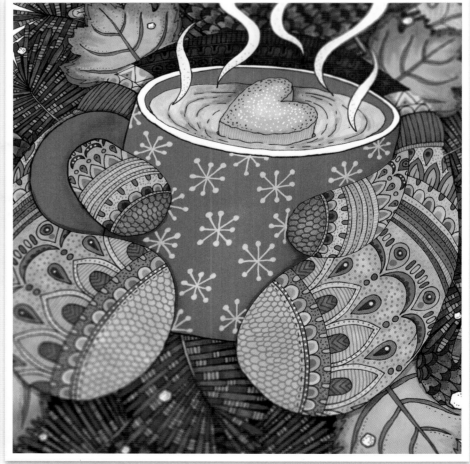

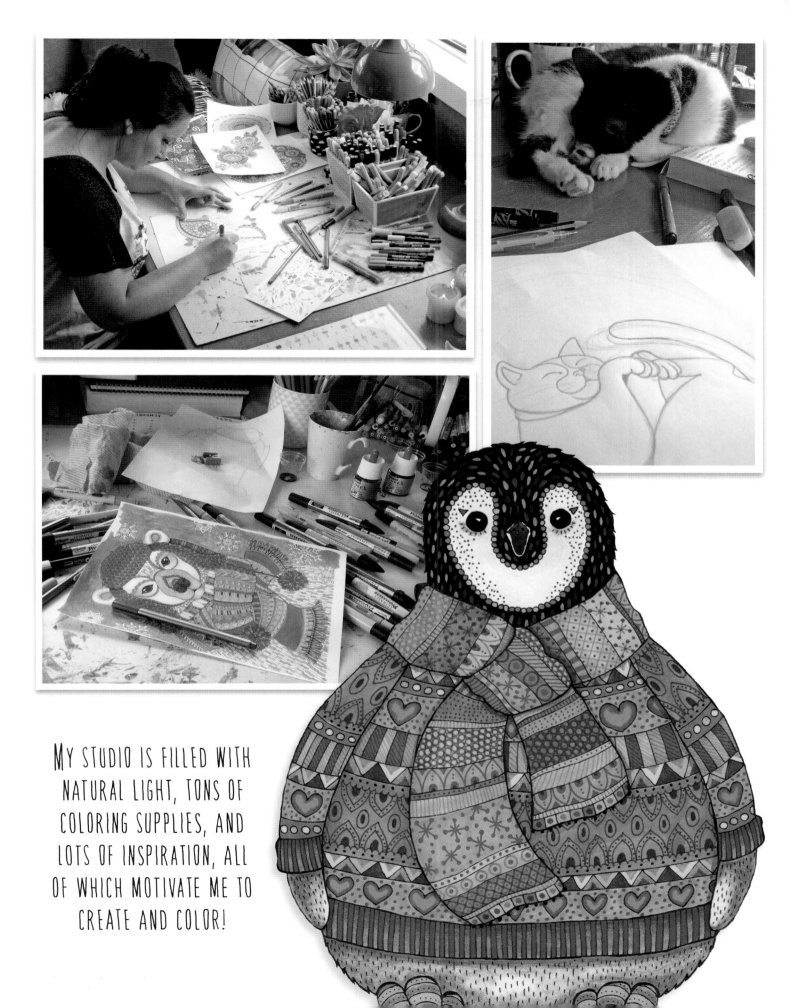

My studio is filled with natural light, tons of coloring supplies, and lots of inspiration, all of which motivate me to create and color!

Where To Start

You might find putting color on a fresh page stressful. It's ok!
Here are a few tricks I use to get the ink flowing.

Start with an easy decision. If a design has leaves, without a doubt, that's where I start. No matter how wacky and colorful everything else gets, I always color the leaves in my illustrations green. I have no reason for it, it's just how it is! Try to find something in the design to help ground you by making an easy color decision: leaves are green, the sky is blue, etc.

Get inspired. Take a good look at everything in the illustration. You chose to color it for a reason. One little piece that you love will jump out and say, "Color me! Use red, please!" Or maybe it will say blue, or pink, or green. Just relax—it will let you know.

Follow your instincts. What colors do you love? Are you a big fan of purple? Or maybe yellow is your favorite. If you love it, use it!

Just go for it. Close your eyes, pick up a color, point to a spot on the illustration, and start! Sometimes starting is the hardest part, but it's the fastest way to finish!

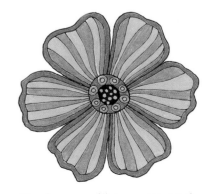

Helpful Hints

There is no right or wrong. All colors work together, so don't be scared to mix it up. The results can be surprising!

Try it. Test your chosen colors on scrap paper before you start coloring your design. You can also test blending techniques and how to use different shapes and patterns for detail work—you can see how different media will blend with or show up on top of your chosen colors. I even use the paper to clean my markers or pens if necessary.

Make a color chart. A color chart is like a test paper for every single color you have! It provides a more accurate way to choose colors than selecting them based on the color of the marker's cap. To make a color chart, color a swatch with each marker, colored pencil, gel pen, etc. Label each swatch with the name or number of the marker so you can easily find it later.

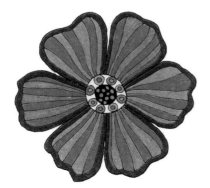

Do you like
warm colors?

How about cool colors?

Maybe you like warm and
cool colors together!

Keep going. Even if you think you've ruined a piece, work through it. I go through the same cycle with my coloring: I love a piece at the beginning, and by the halfway point I nearly always dislike it. Sometimes by the end I love it again, and sometimes I don't, and that's ok. It's important to remember that you're coloring for you— no one else. If you really don't like a piece at the end, stash it away and remember that you learned something. You know what not to do next time. My studio drawers are full of everything from duds to masterpieces!

Be patient. Let markers, gel pens, and paints dry thoroughly between each layer. There's nothing worse than smudging a cluster of freshly inked dots across the page with your hand. Just give them a minute to dry and you can move on to the next layer.

Use caution. Juicy/inky markers can "spit" when you uncap them. Open them away from your art piece.

Work from light to dark. It's much easier to make something darker gradually than to lighten it.

Shade with gray. A mid-tone lavender-gray marker is perfect for adding shadows to your artwork, giving it depth and making it pop right off the page!

Try blending fluid. If you like working with alcohol-based markers, a refillable bottle of blending fluid or a blending pen is a great investment. Aside from enabling you to easily blend colors together, it can help clean up unwanted splatters or mistakes—it may not take some colors away completely, but it will certainly lighten them. I use it to clean the body of my markers as I'm constantly smudging them with inky fingers. When a marker is running out of ink, I find adding a few drops of blending fluid to the ink barrel will make it last a bit longer.

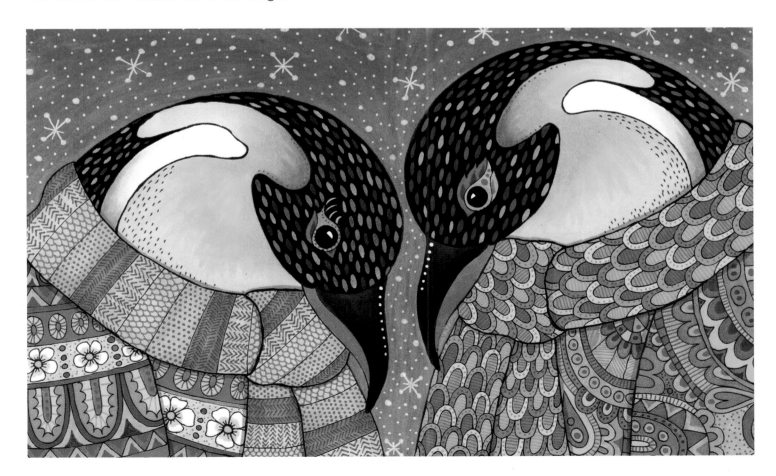

Layering and Blending

I love layering and blending colors. It's a great way to create shading and give your finished piece lots of depth and dimension. The trick is to work from the lightest color to the darkest and then go over everything again with the lightest shade to keep the color smooth and bring all the layers together.

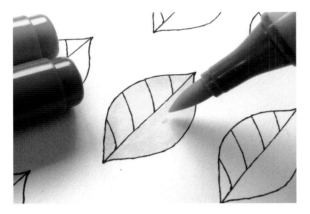

1 Apply a base layer with the lightest color.

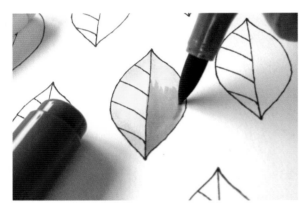

2 Add the middle color, using it to create shading.

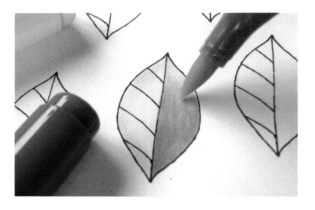

3 Smooth out the color by going over everything with the lightest color.

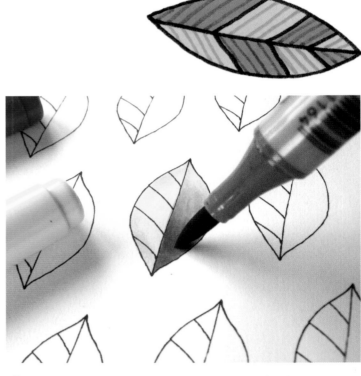

4 Add the darkest color, giving your shading even more depth. Use the middle color to go over the same area you colored in Step 2.

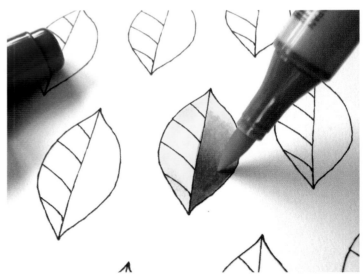

5 Go over everything with the lightest color as you did in Step 3.

Patterning and Details

Layering and blending will give your coloring depth and dimension. Adding patterning and details will really bring it to life. If you're not convinced, try adding a few details to one of your colored pieces with a white gel pen—that baby will make magic happen! Have fun adding all of the dots, doodles, and swirls you can imagine.

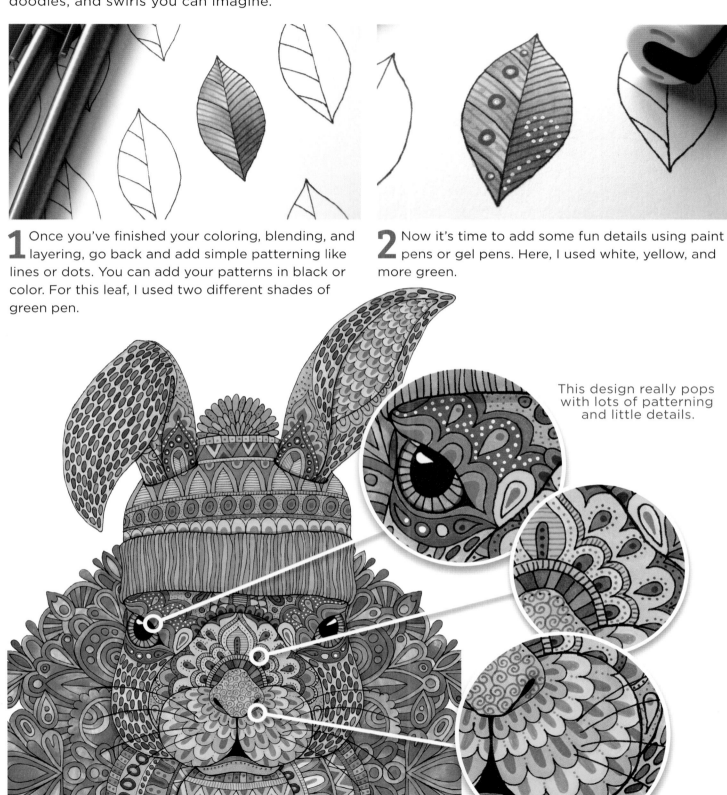

1 Once you've finished your coloring, blending, and layering, go back and add simple patterning like lines or dots. You can add your patterns in black or color. For this leaf, I used two different shades of green pen.

2 Now it's time to add some fun details using paint pens or gel pens. Here, I used white, yellow, and more green.

This design really pops with lots of patterning and little details.

Coloring Supplies

I'm always asked about the mediums I use to color my illustrations. The answer would be really long if I listed every single thing, so here are a few of my favorites. Keep in mind, these are *my* favorites. When you color, you should use YOUR favorites!

Alcohol-based markers. I have many, and a variety of brands. My favorites have a brush nib—it's so versatile. A brush nib is perfect for tiny, tight corners, but also able to cover a large, open space easily. I find I rarely get streaking, and if I do, it's usually because the ink is running low!

Fine-tip pens. Just like with markers, I have lots of different pens. I use them for my layers of detail work and for the itsy bitsy spots my markers can't get into.

Paint pens. These are wonderful! Because the ink is usually opaque, they stand out really well against a dark base color. I use extra fine point pens for their precision. Some paint pens are water based, so I can use a brush to blend the colors and create a cool watercolor effect.

Gel pens. I have a few, but I usually stick to white and neon colors that will stand out on top of dark base colors or other mediums.

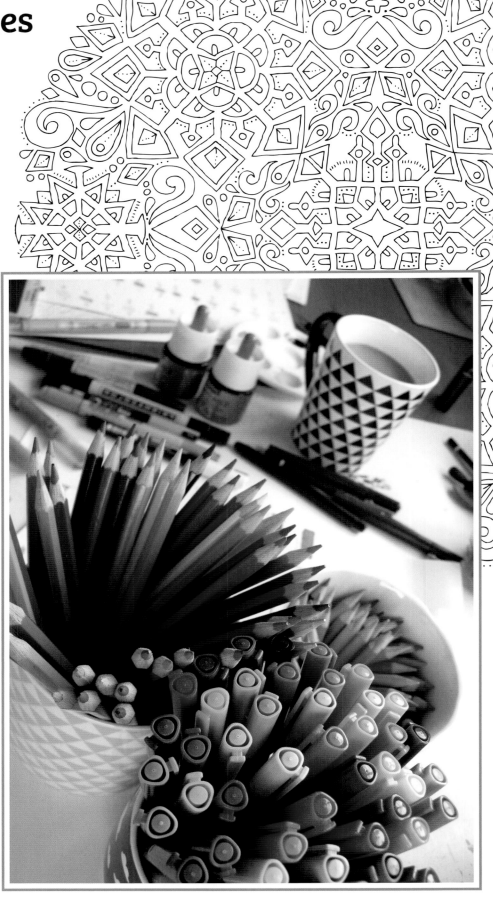

Hello Angel #1233, markers, pens, paint pens

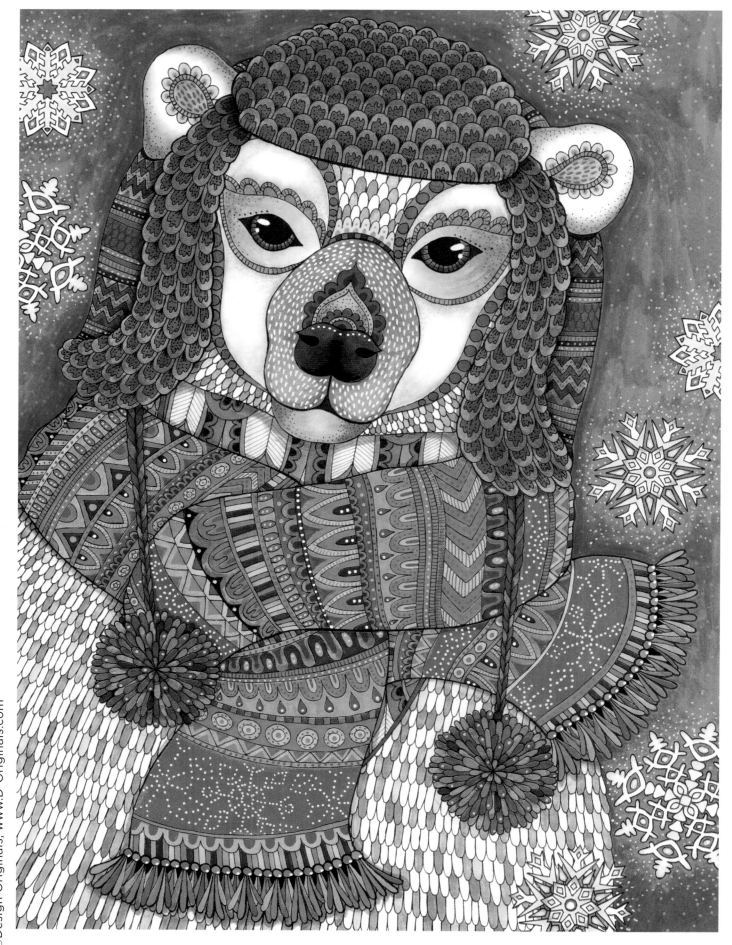

Hello Angel #1234, liquid watercolor, colored pencils, pens, paint pens, markers

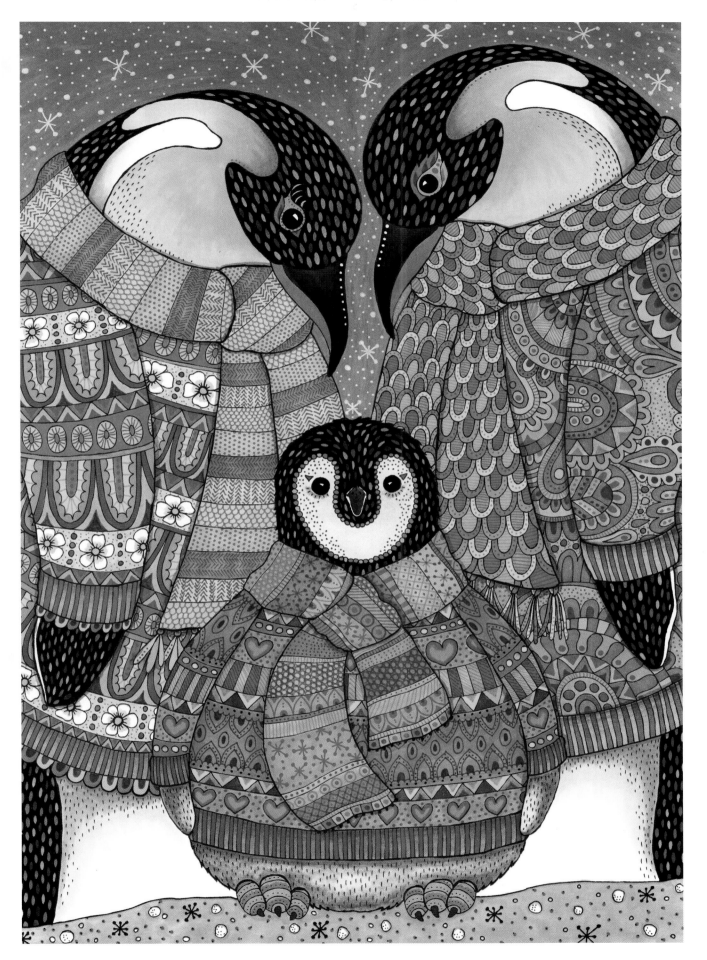

Hello Angel #1235, liquid watercolor, colored pencils, pens, paint pens, markers

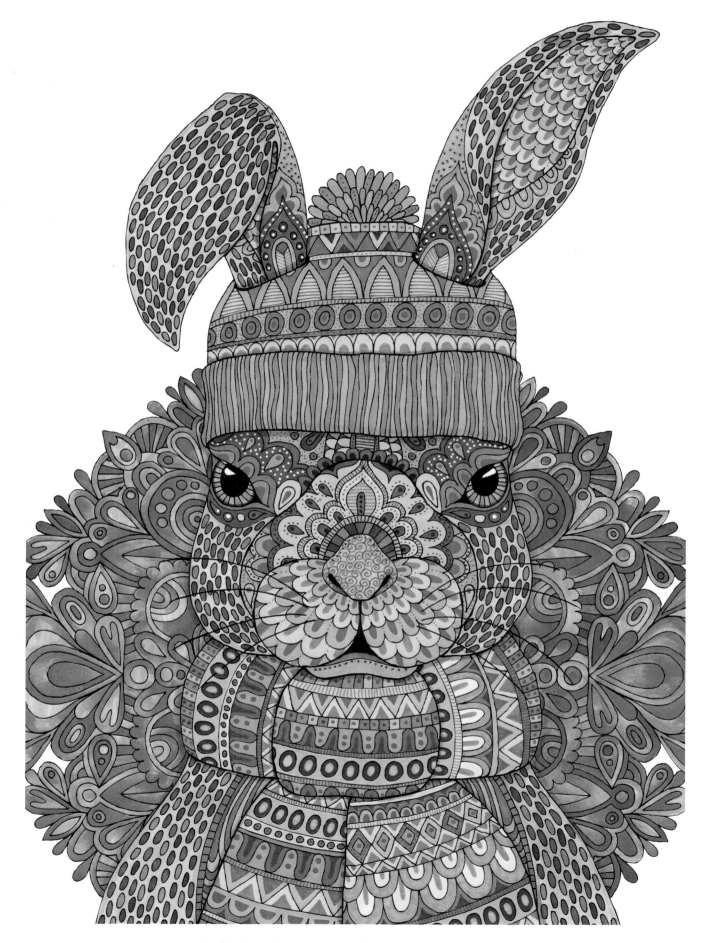

Hello Angel #1236, markers, pens, paint pens

Hello Angel #1237, liquid watercolor, paint pens, markers

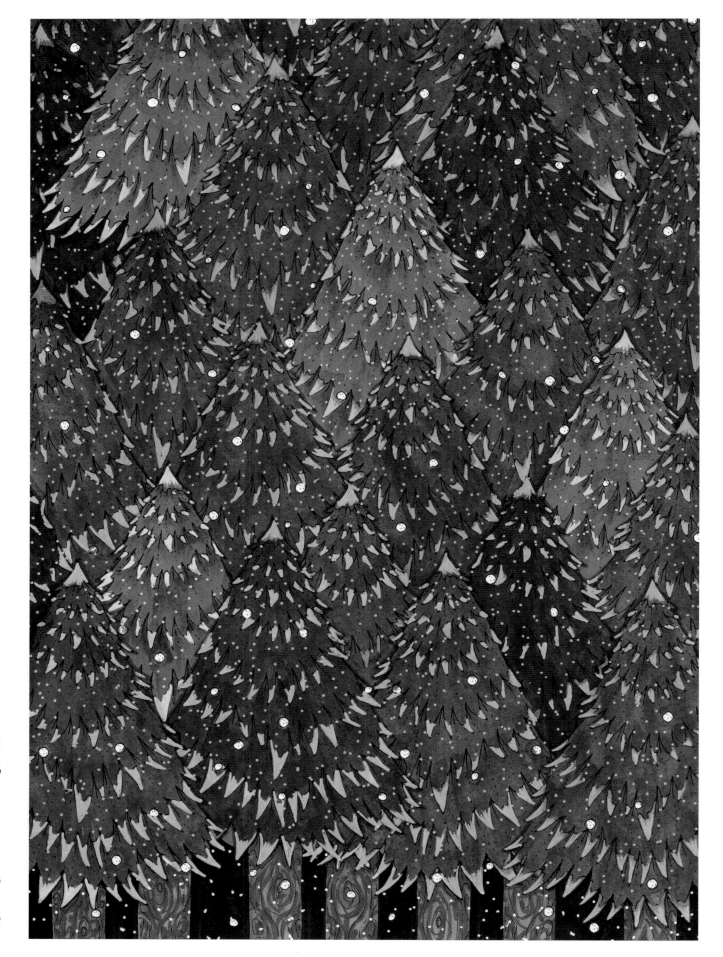

Hello Angel #1249, liquid watercolor, colored pencils, paint pens, markers

Hello Angel #1250, markers, pens, paint pens

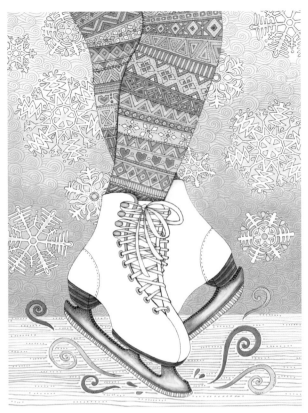

Hello Angel #1251, liquid watercolor,
colored pencils, pens, paint pens, markers

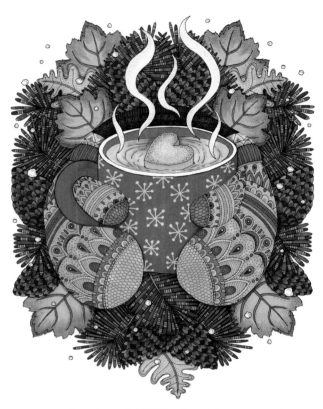

Hello Angel #1252, liquid watercolor,
colored pencils, pens, paint pens, markers

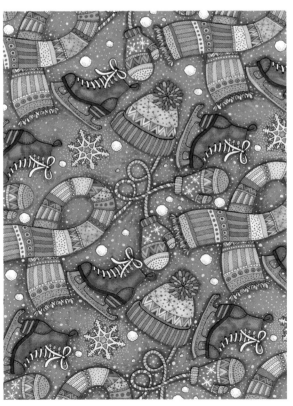

Hello Angel #1253, liquid watercolor,
colored pencils, pens, paint pens, markers

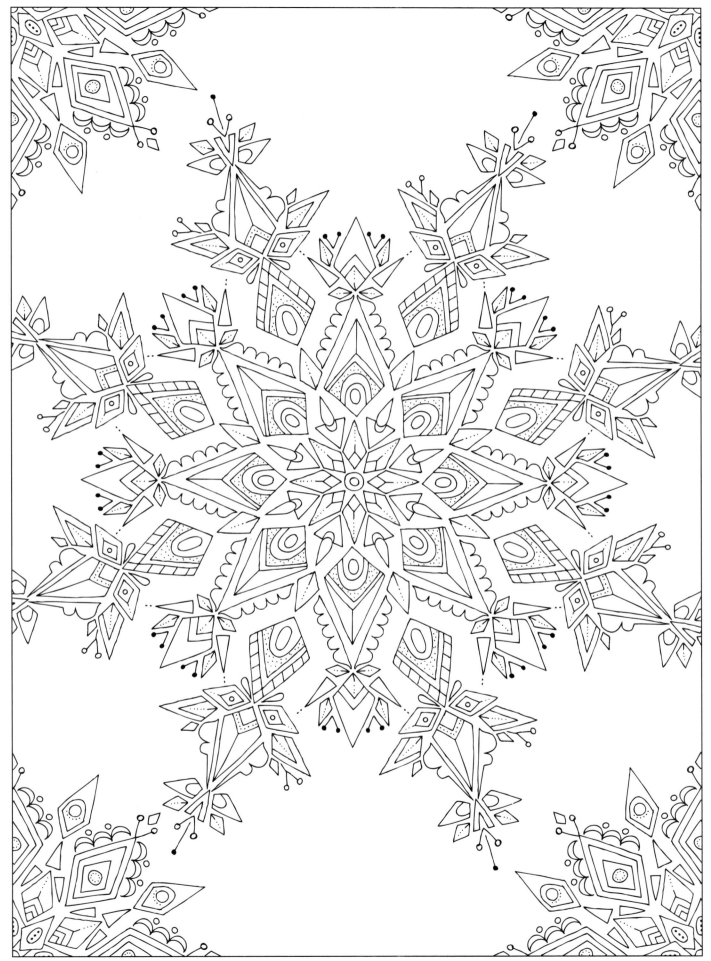

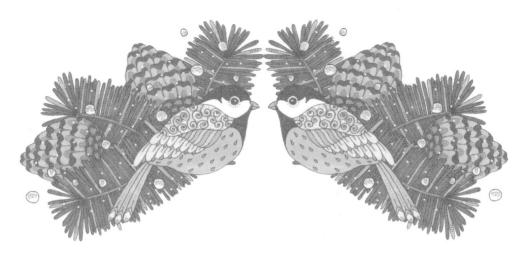

Snow provokes responses
that reach right back to childhood.

—ANDY GOLDSWORTHY

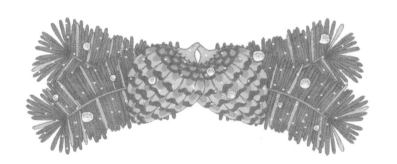

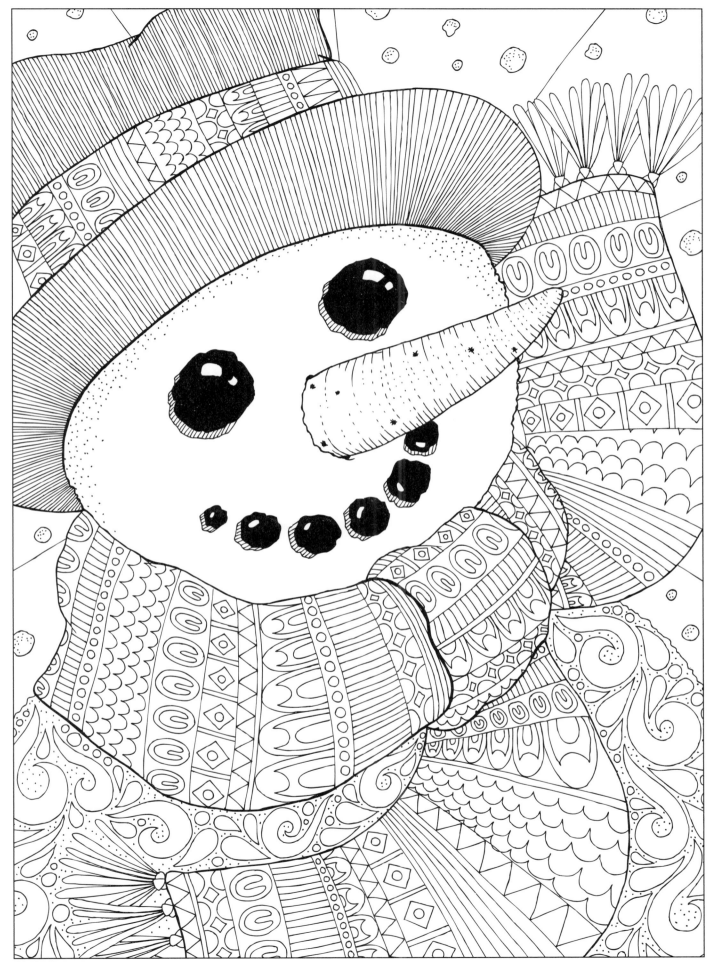

Snowflakes are one of nature's most fragile things, but just look at what they can do when they stick together.

—Unknown

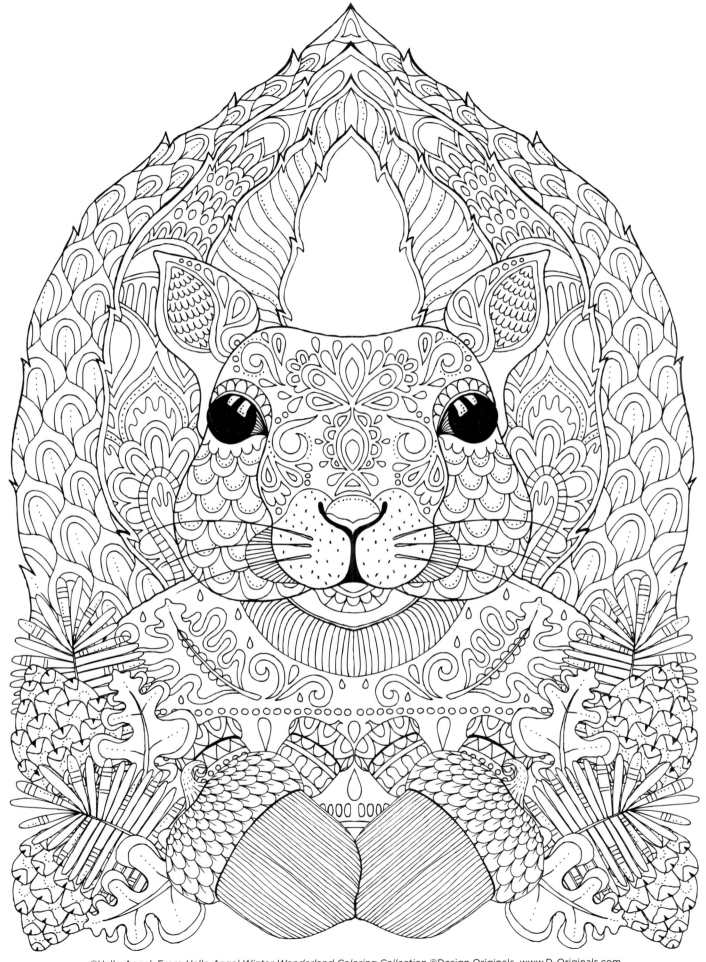

Winter was made for
warm blankets and large books.

—UNKNOWN

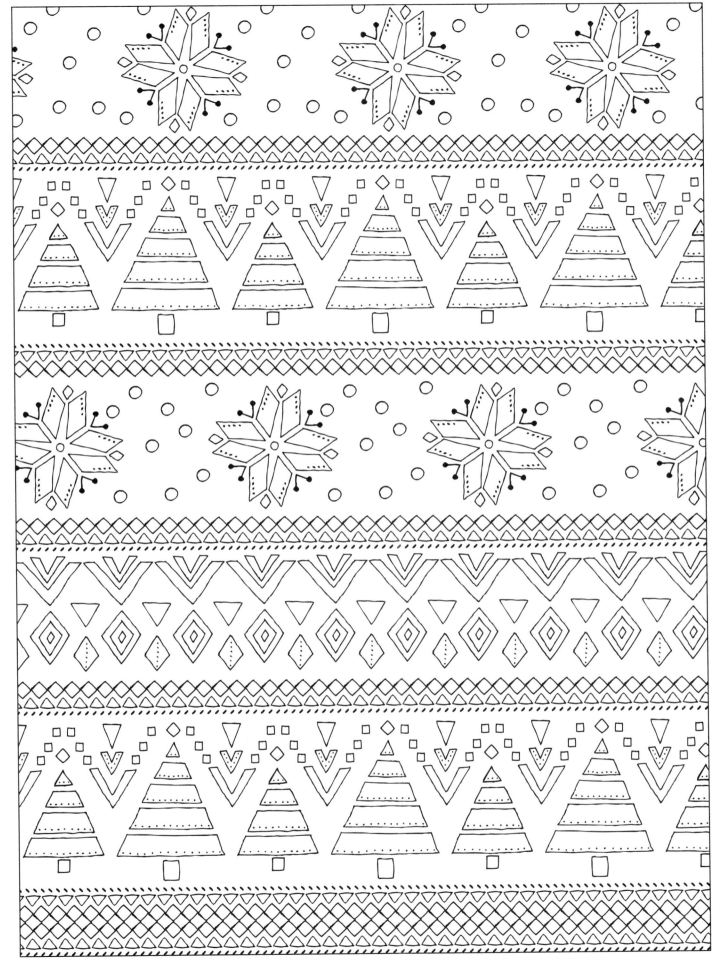

Winter reminds us that everyone
and everything needs some quiet time.

—KATRINA MAYER

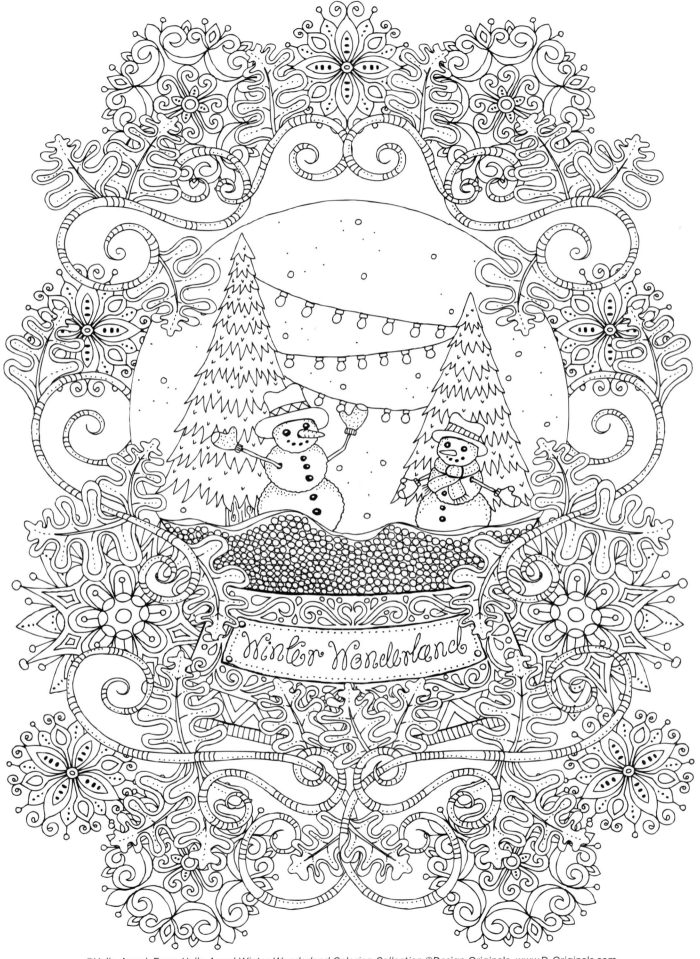

Winter Wonderland

When it snows, ain't it thrilling,
though your nose gets a chilling, we'll frolic and play,
the Eskimo way, walking in a winter wonderland.

—*WINTER WONDERLAND*

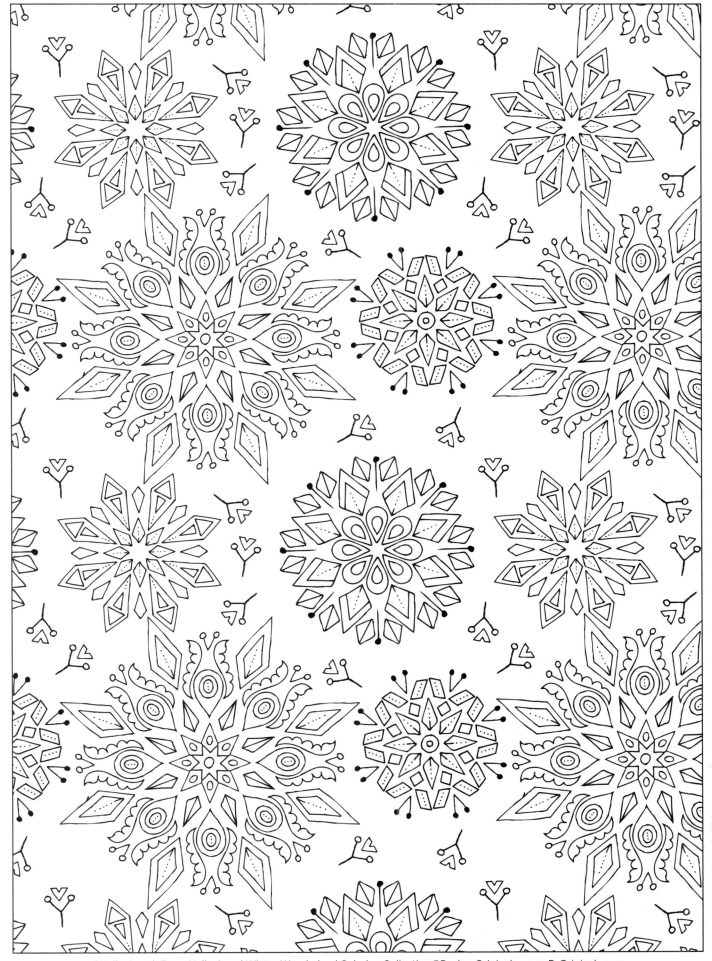

Deep within the winter forest, among the snowdrift wide, you can find a magic place, where all the fairies hide.

—Unknown

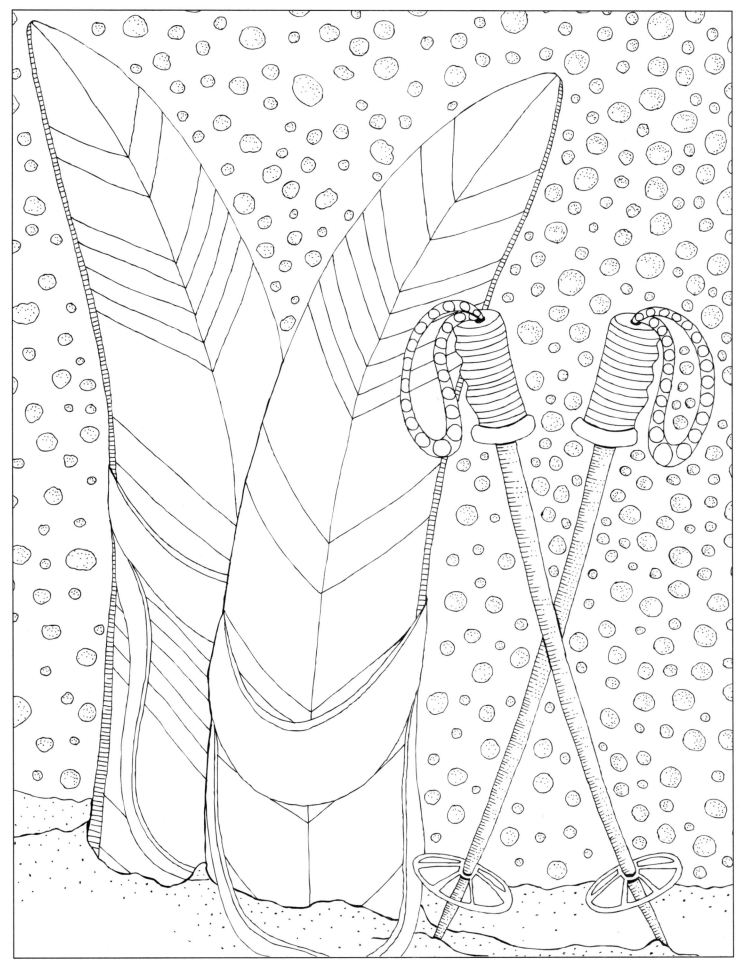

Winter came down to our home
one night, quietly pirouetting in on
silvery-toed slippers of snow, and we,
we were children once again.

—BILL MORGAN, JR.

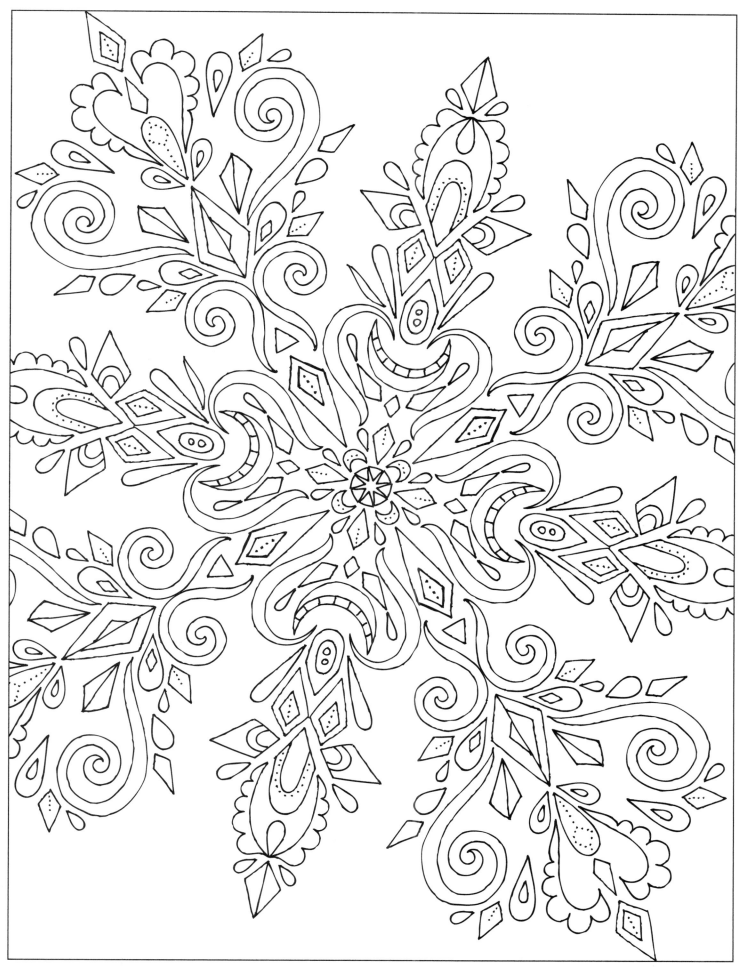

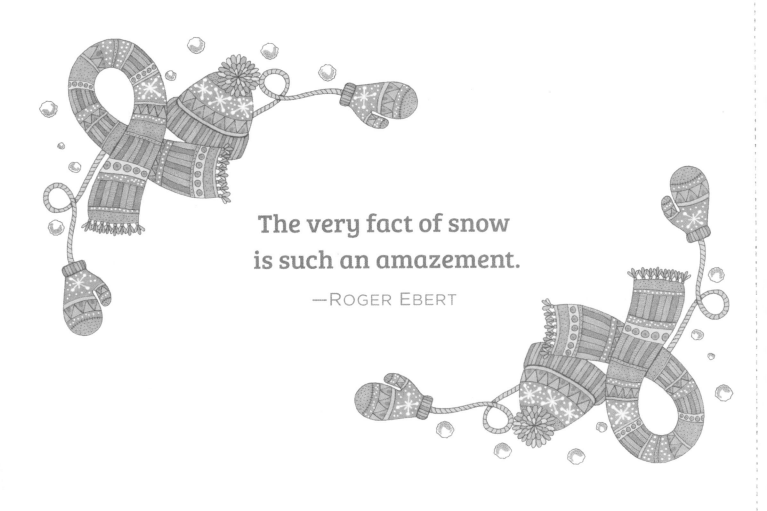

The very fact of snow
is such an amazement.

—ROGER EBERT

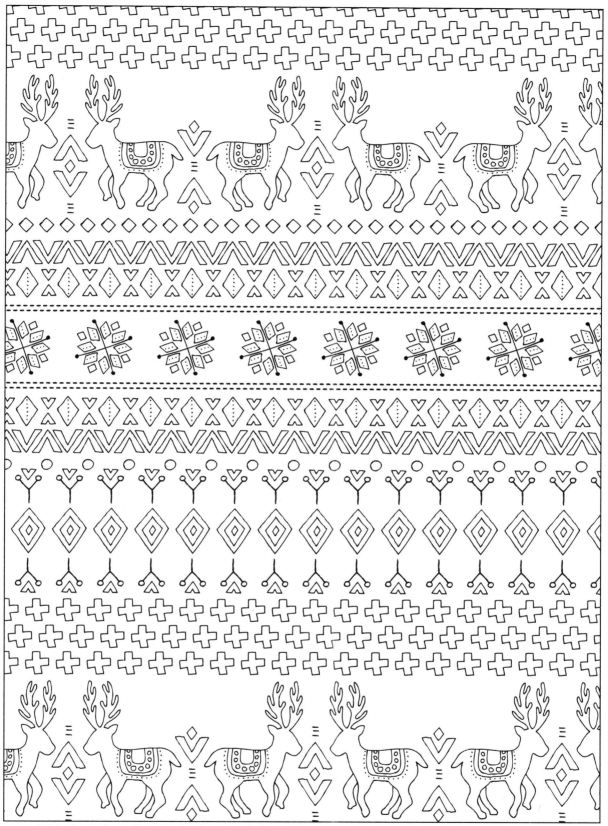

The color of springtime is in the flowers;
the color of winter is in the imagination.

—Unknown

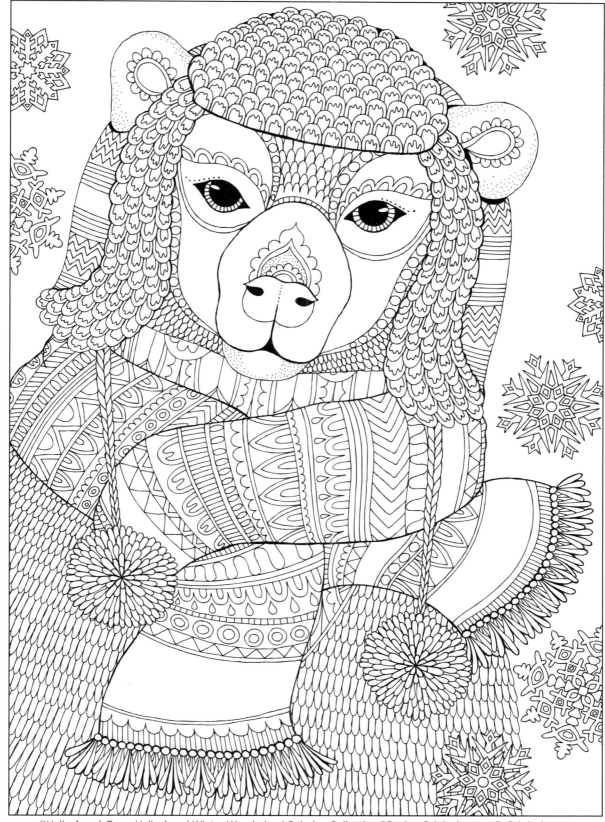

©Hello Angel, From *Hello Angel Winter Wonderland Coloring Collection* ©Design Originals, www.D-Originals.com

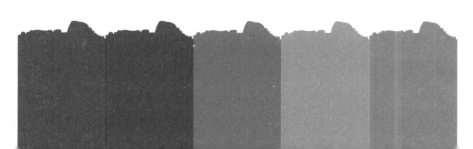

Winter is not a season, it's a celebration.

—Unknown

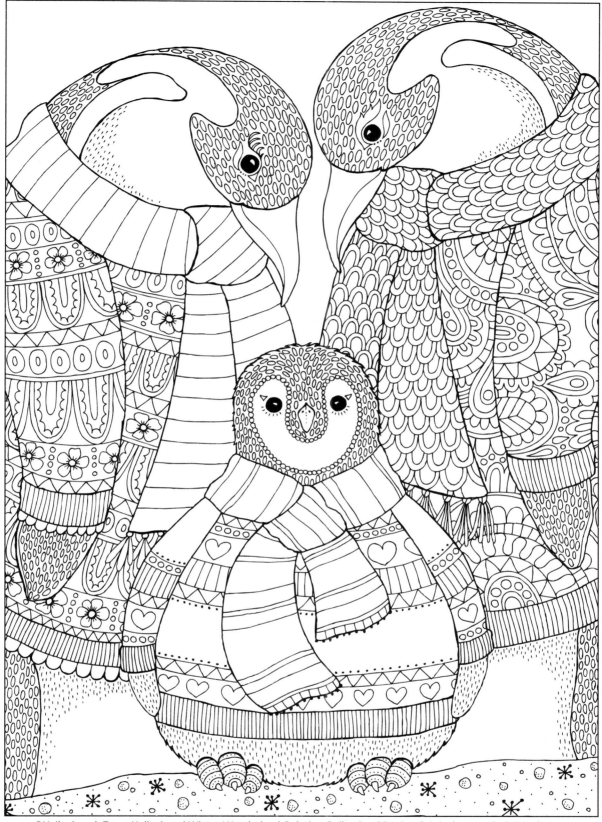

©Hello Angel, From *Hello Angel Winter Wonderland Coloring Collection* ©Design Originals, www.D-Originals.com

Winter is the time for comfort, for
good food and warmth, for the touch
of a friendly hand and for a talk
beside the fire: it is the time for home.

—EDITH SITWELL

Hello Angel #1235

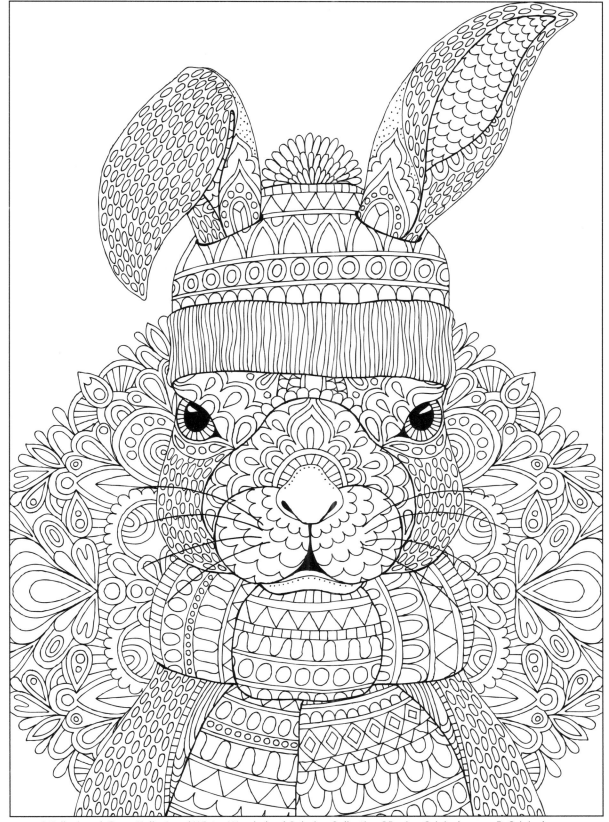

©Hello Angel, From *Hello Angel Winter Wonderland Coloring Collection* ©Design Originals, www.D-Originals.com

First we'll make snow angels for two hours, then we'll go ice skating, then we'll eat a whole roll of Toll House cookie dough as fast as we can, and then we'll snuggle.

—*ELF*

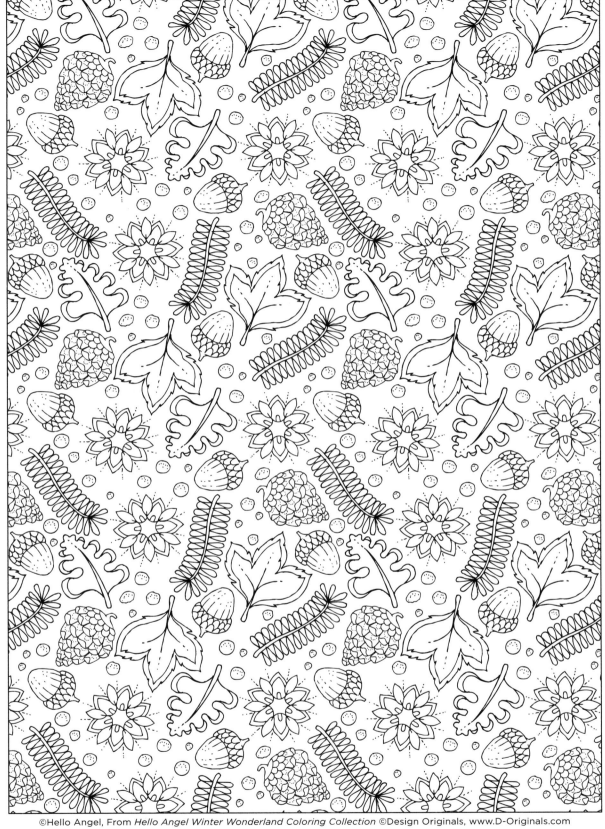

©Hello Angel, From *Hello Angel Winter Wonderland Coloring Collection* ©Design Originals, www.D-Originals.com

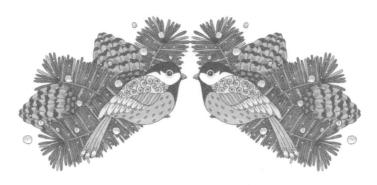

While I relish our warm months, winter forms
our character and brings out our best.

—TOM ALLEN

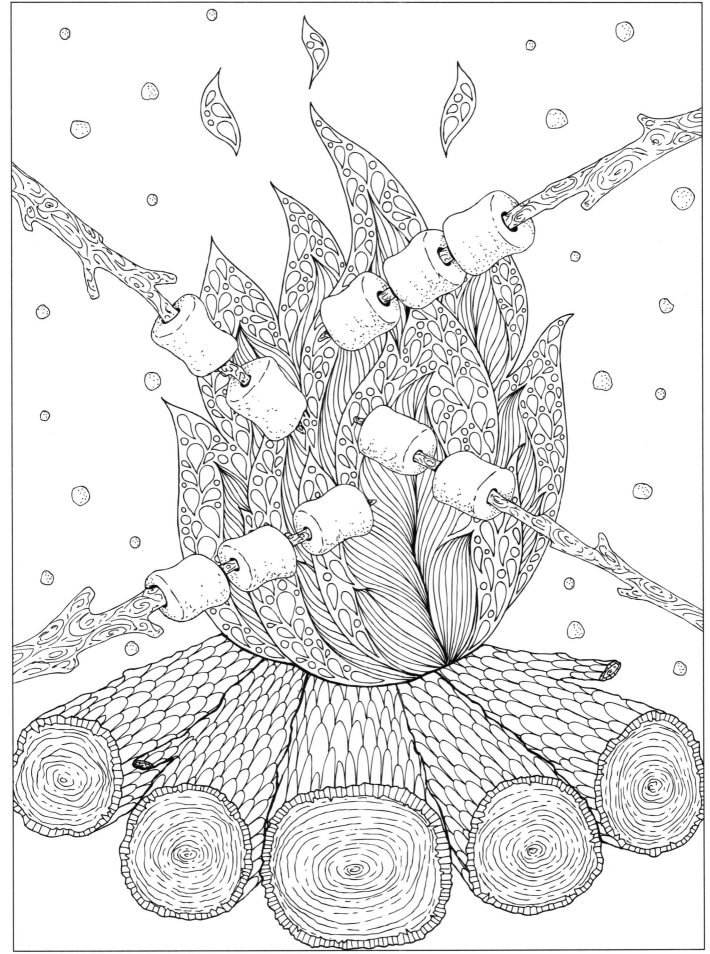

Like campfires and marshmallows,
we're better together.

—UNKNOWN

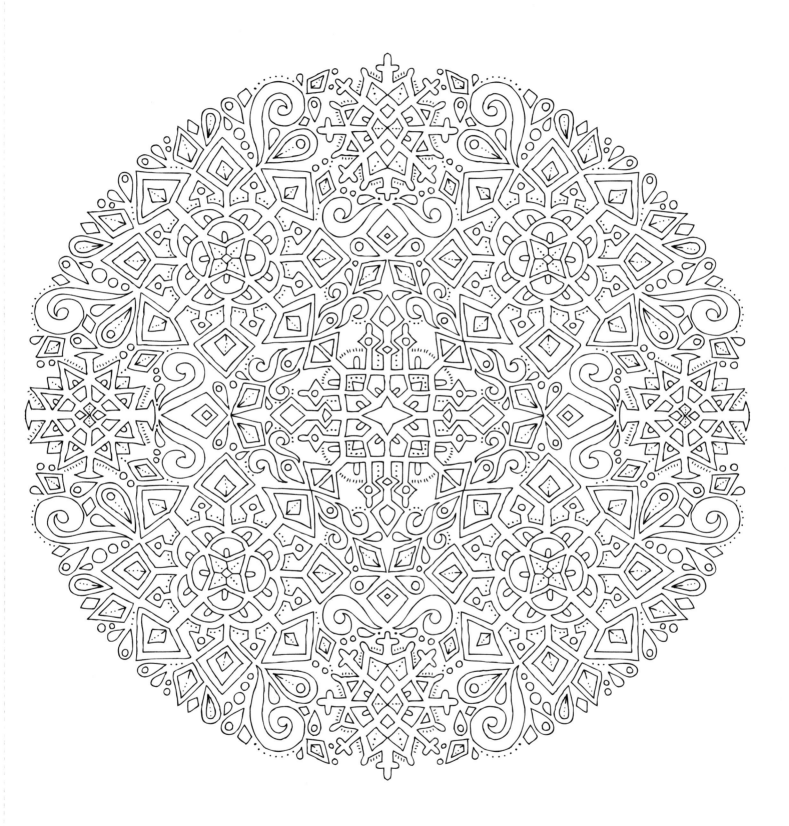

The snow is sparkling
like a million little suns.

—LAMA WILLA MILLER

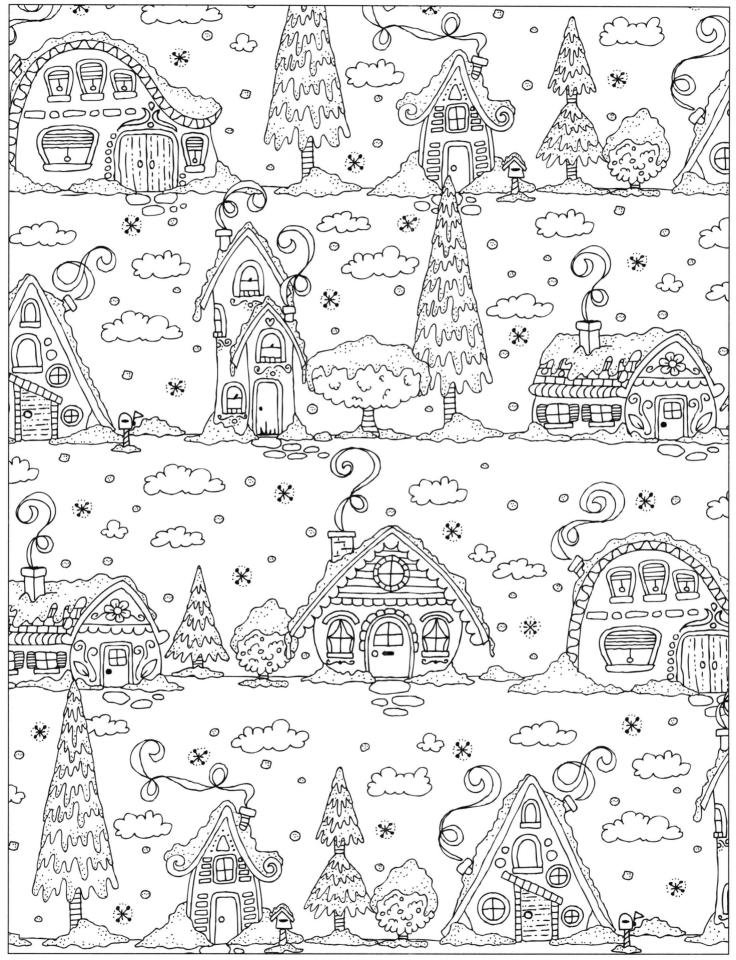

What good is the warmth
of summer without the cold of winter
to give it sweetness.

—JOHN STEINBECK

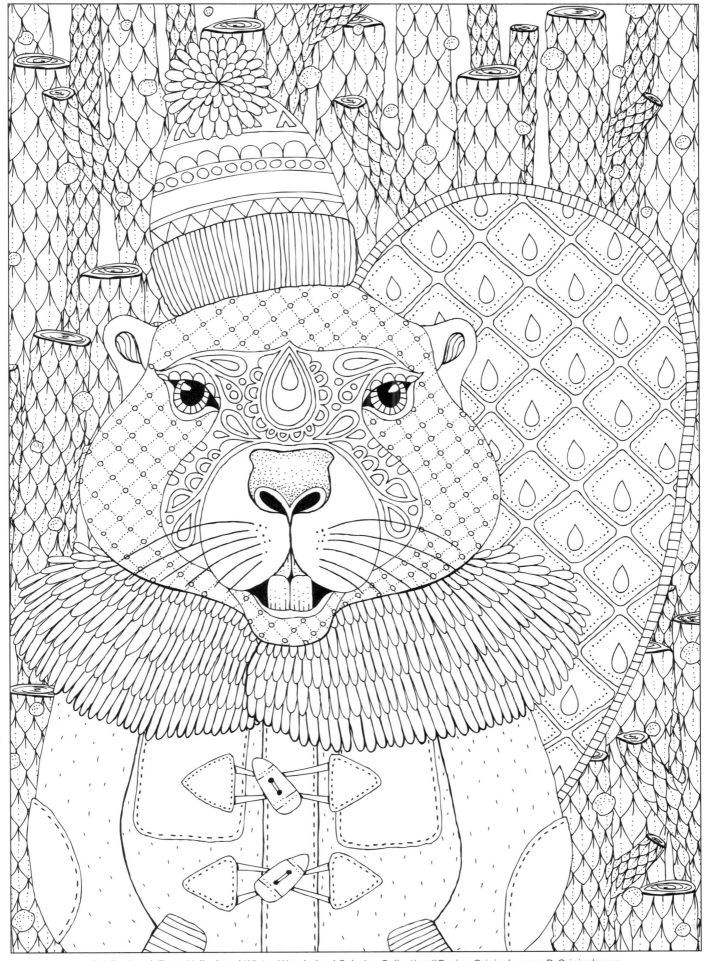

There is nothing in the world so irresistibly contagious as laughter and good humor.

—CHARLES DICKENS, *A CHRISTMAS CAROL*

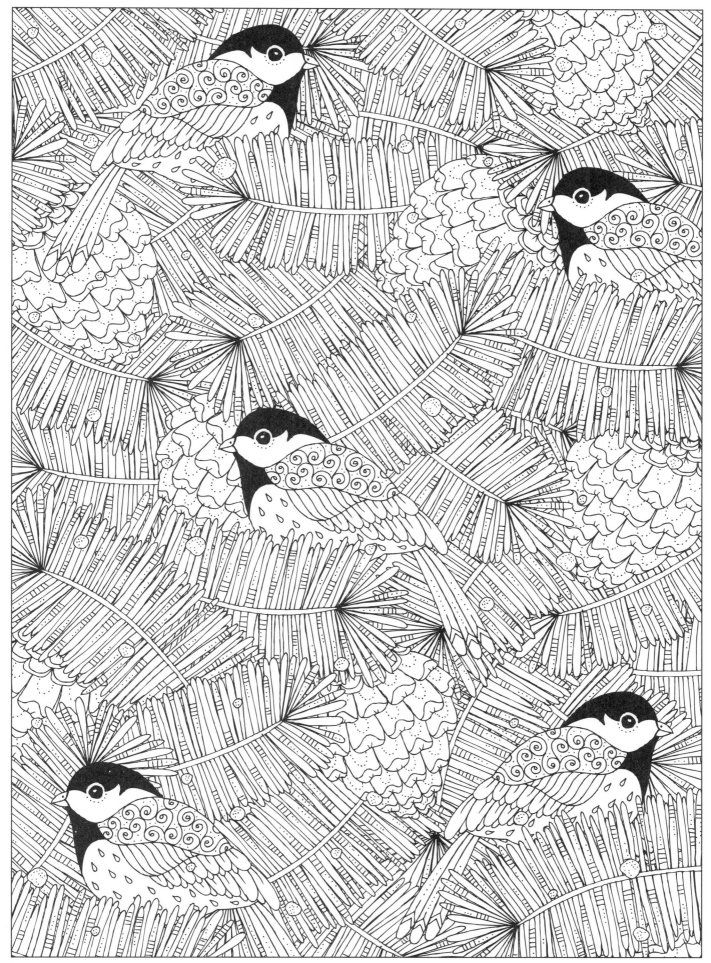

In seed time learn, in harvest teach, in winter enjoy.

—WILLIAM BLAKE

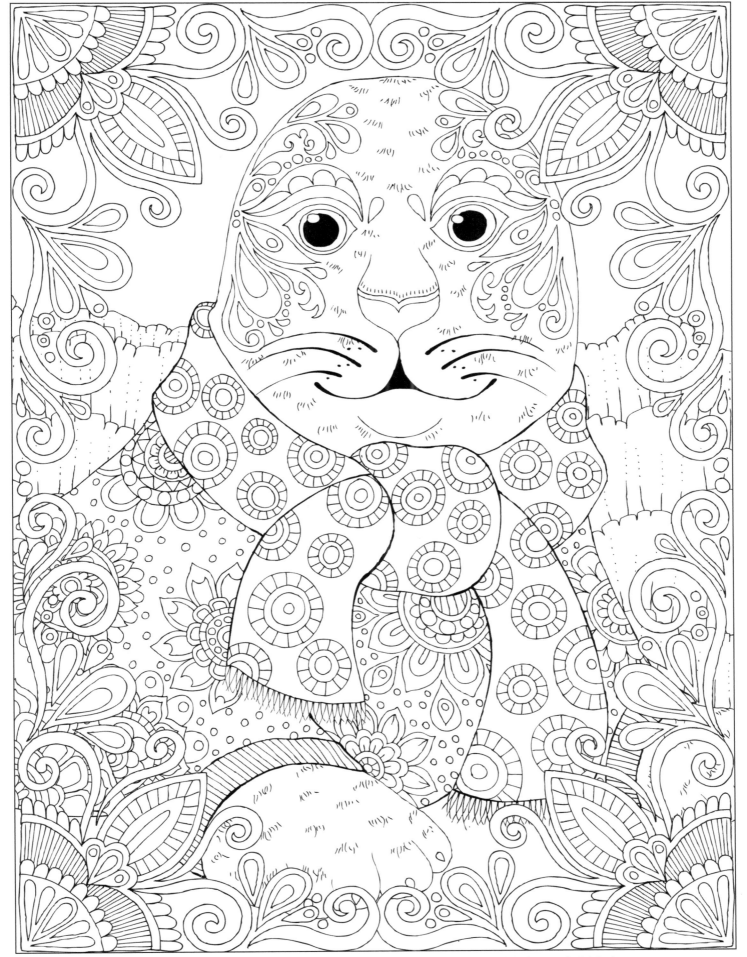

To appreciate the beauty
of a snowflake, it is necessary to
stand out in the cold.

—Unknown

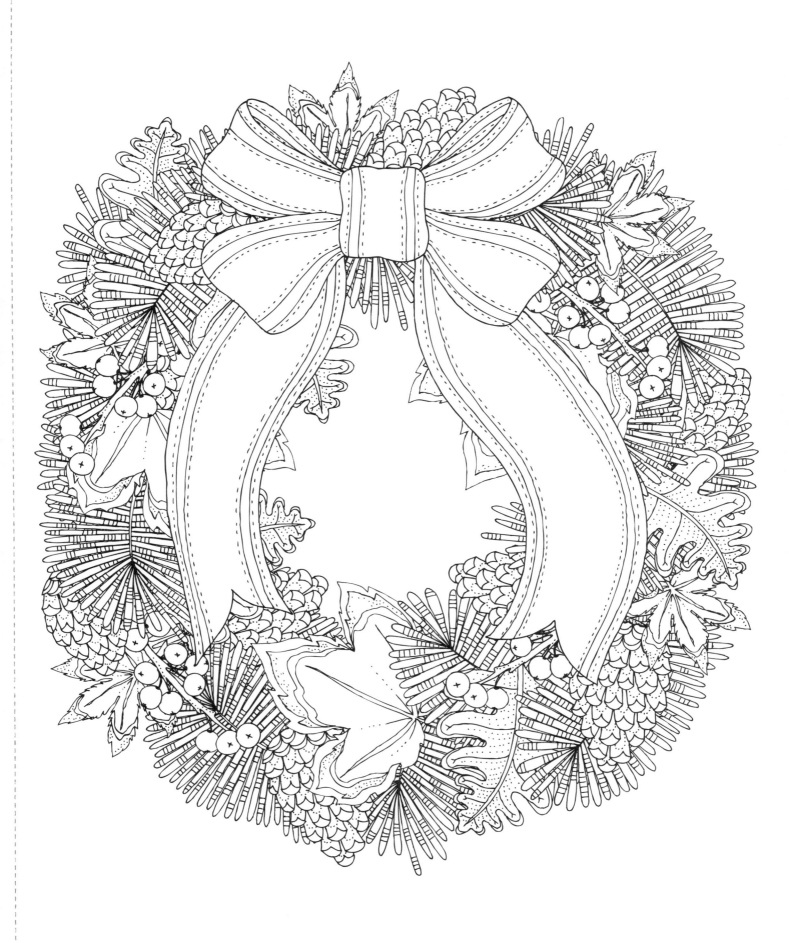

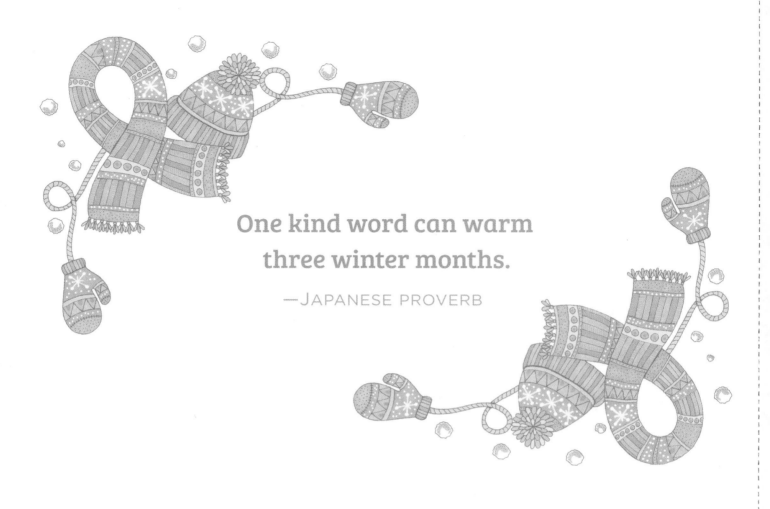

One kind word can warm
three winter months.

—JAPANESE PROVERB

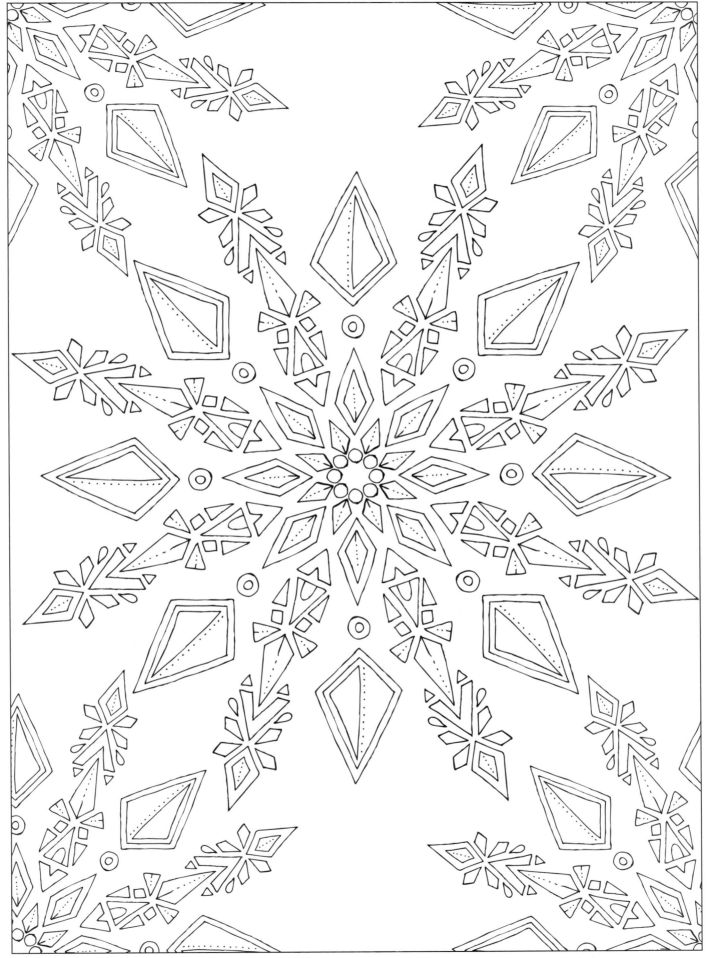

Kindness is like snow —
it beautifies everything it covers.

—Kahlil Gibran

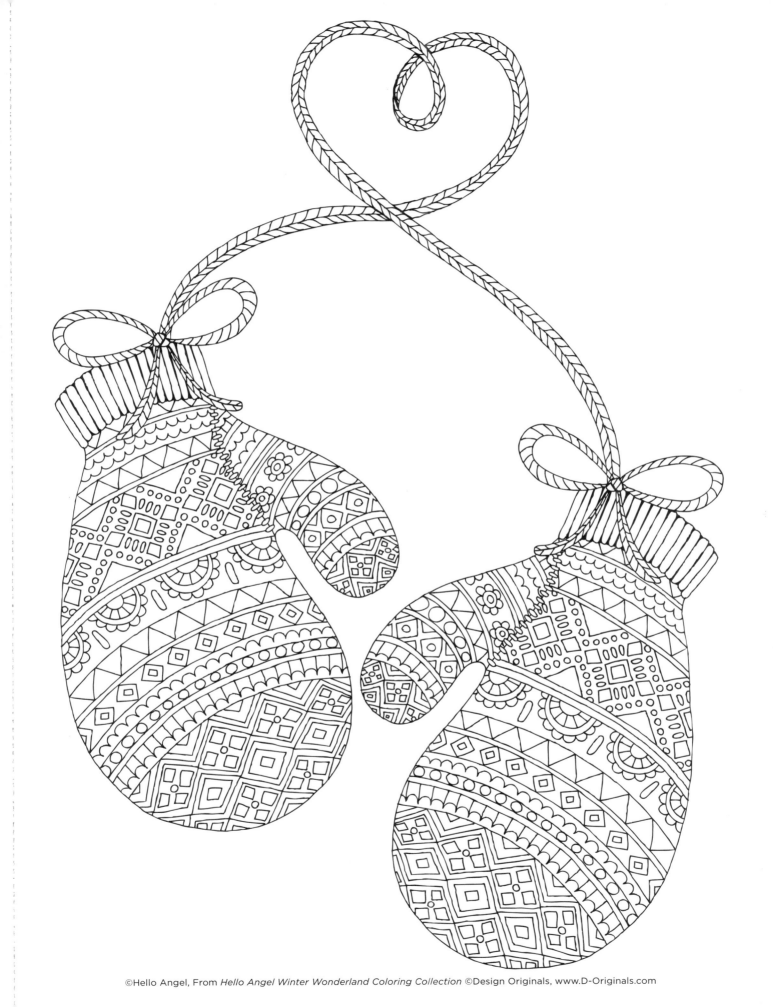

Red mittens to keep my hands
warm as toast, on cold winter days,
when I skate or coast.

—CHILDREN'S SONG

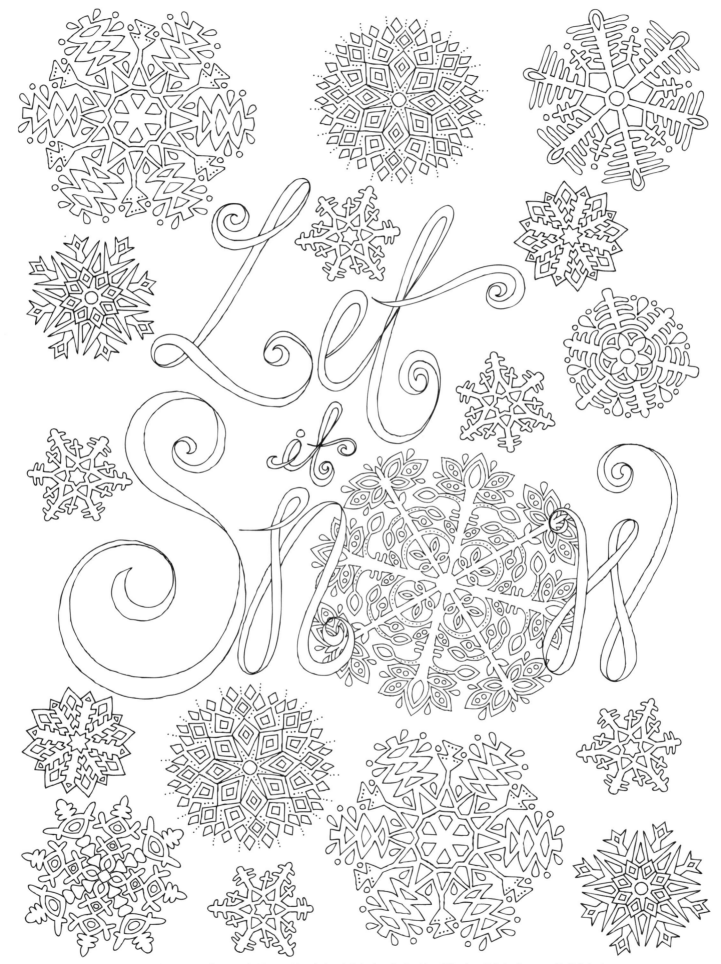

Oh the weather outside is
frightful, but the fire is so delightful,
and since we've no place to go,
let it snow! let it snow! let it snow!

—*LET IT SNOW*

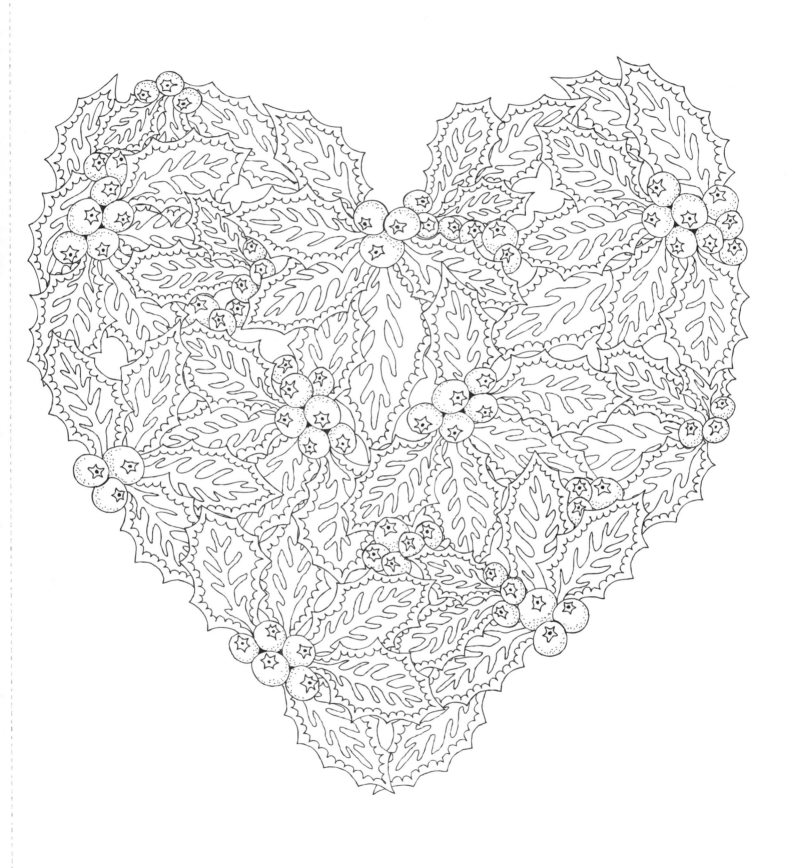

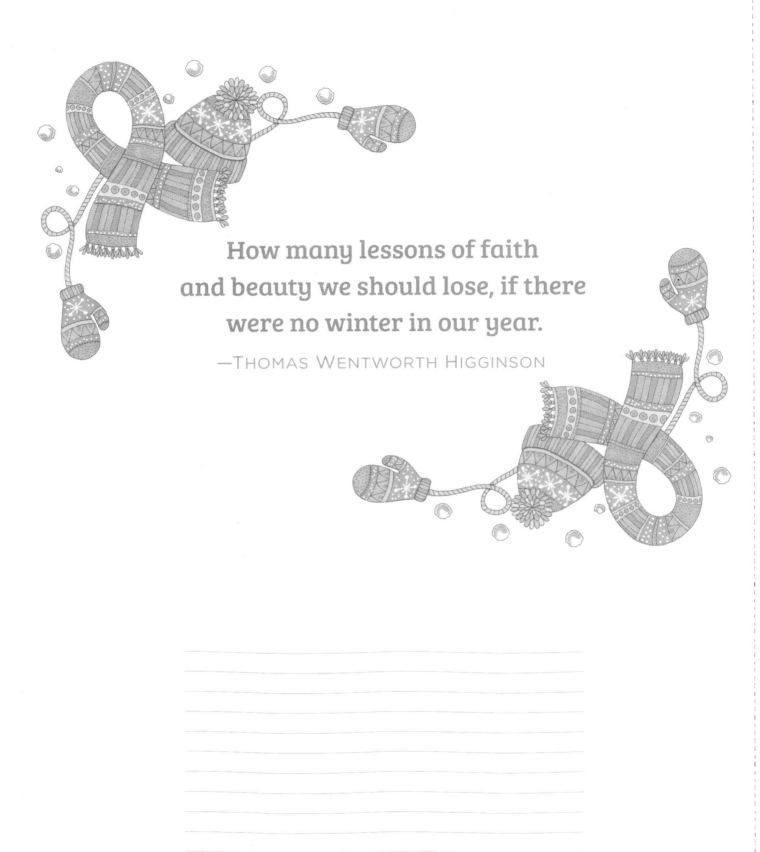

How many lessons of faith
and beauty we should lose, if there
were no winter in our year.

—Thomas Wentworth Higginson

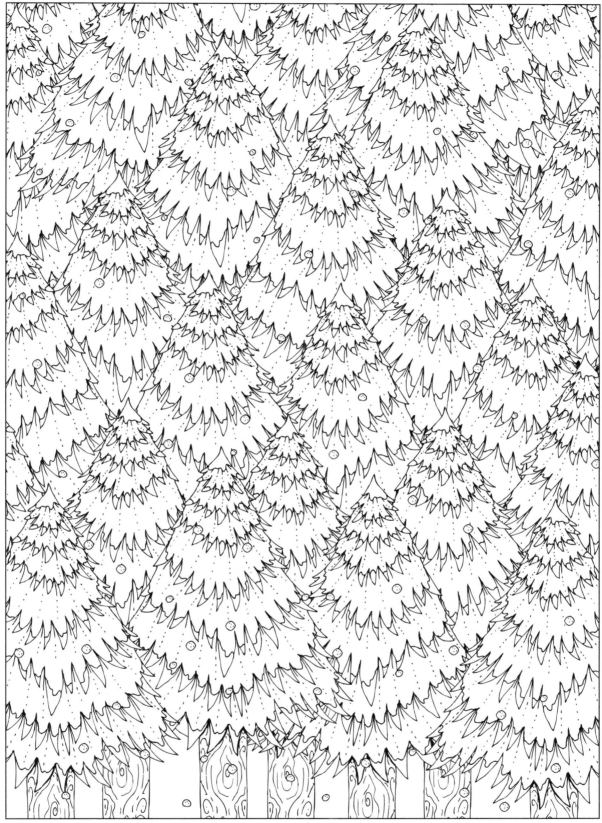

©Hello Angel, From *Hello Angel Winter Wonderland Coloring Collection* ©Design Originals, www.D-Originals.com

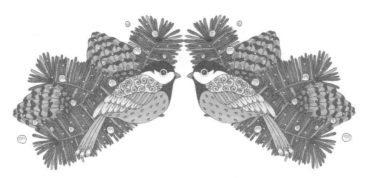

Snow was falling, so much like stars, filling
the dark trees, that one could easily imagine, its reason
for being was nothing more than prettiness.

—MARY OLIVER, *SNOWY NIGHT*

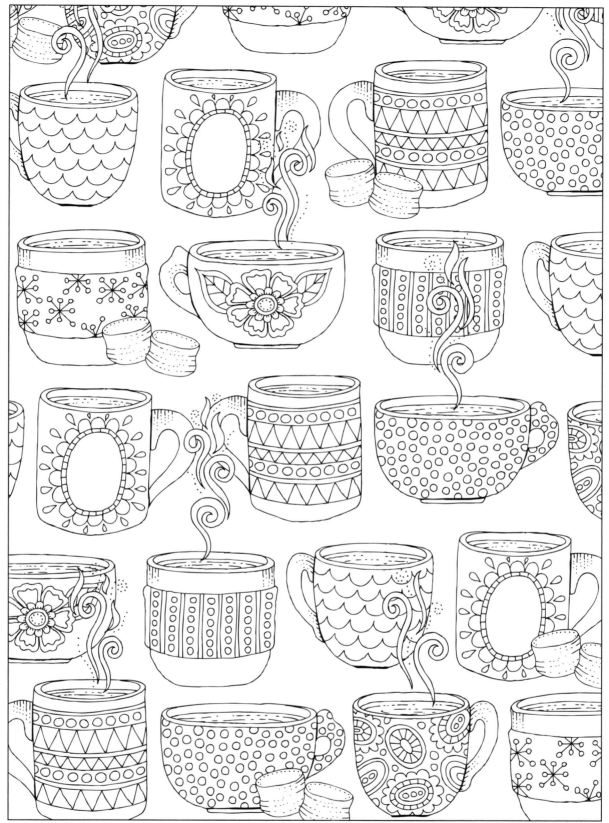

©Hello Angel, From *Hello Angel Winter Wonderland Coloring Collection* ©Design Originals, www.D-Originals.com

All you need is tea and warm socks.

—Unknown

Hello Angel #1250

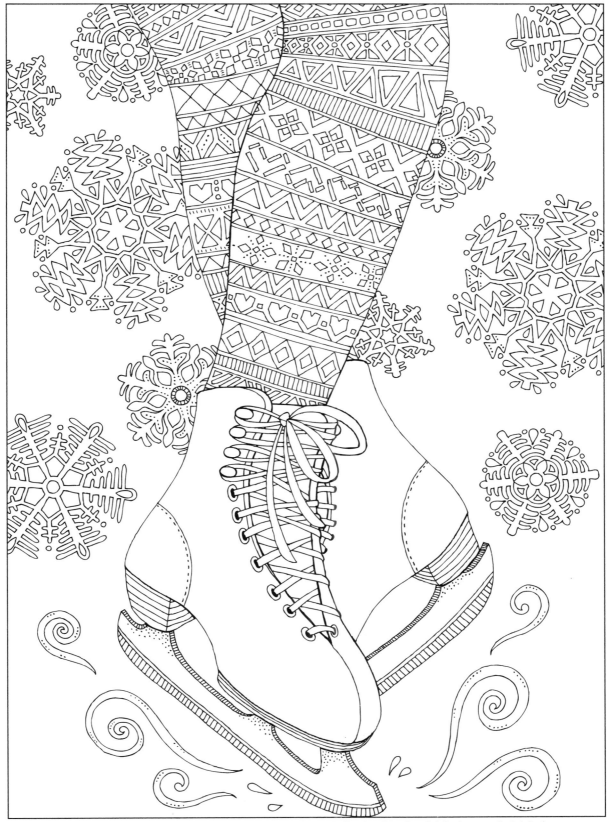

©Hello Angel, From *Hello Angel Winter Wonderland Coloring Collection* ©Design Originals, www.D-Originals.com

I fell in love the day I touched the ice.

—UNKNOWN

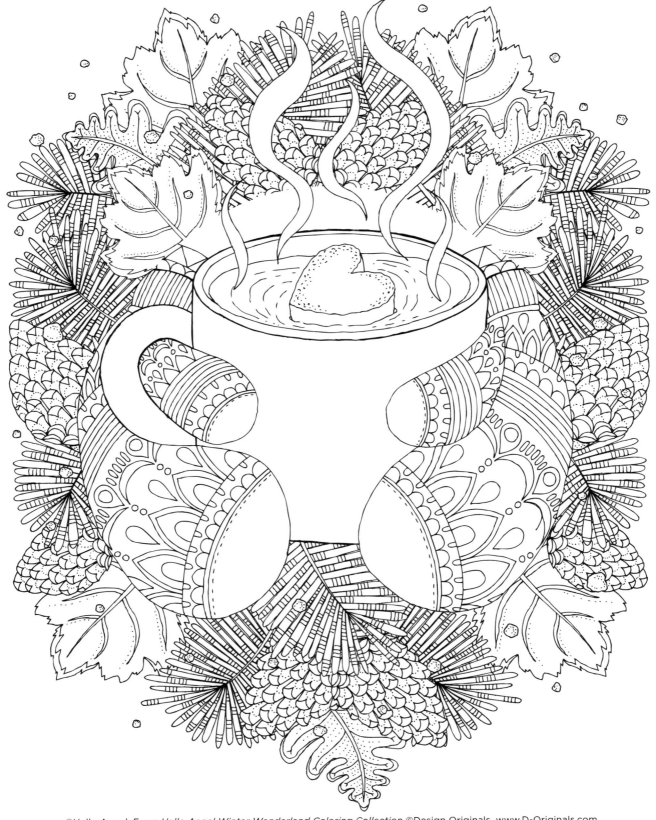

©Hello Angel, From *Hello Angel Winter Wonderland Coloring Collection* ©Design Originals, www.D-Originals.com

To me hot chocolate always
felt like a hug from the inside.

—W. R. ELPIS, *A SHADOW OF BLUE LOVE*

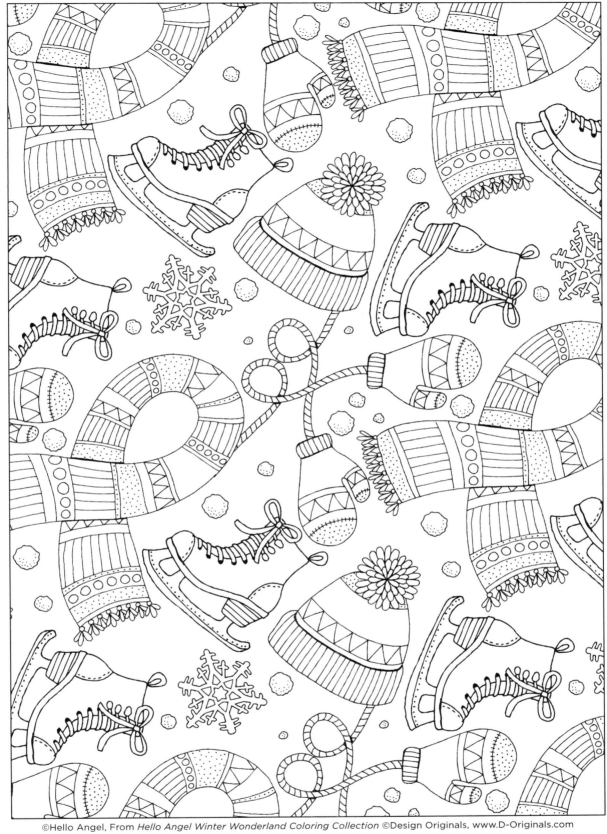

©Hello Angel, From *Hello Angel Winter Wonderland Coloring Collection* ©Design Originals, www.D-Originals.com

I'll never outgrow the excitement of
looking out my window and seeing falling snow.

—UNKNOWN

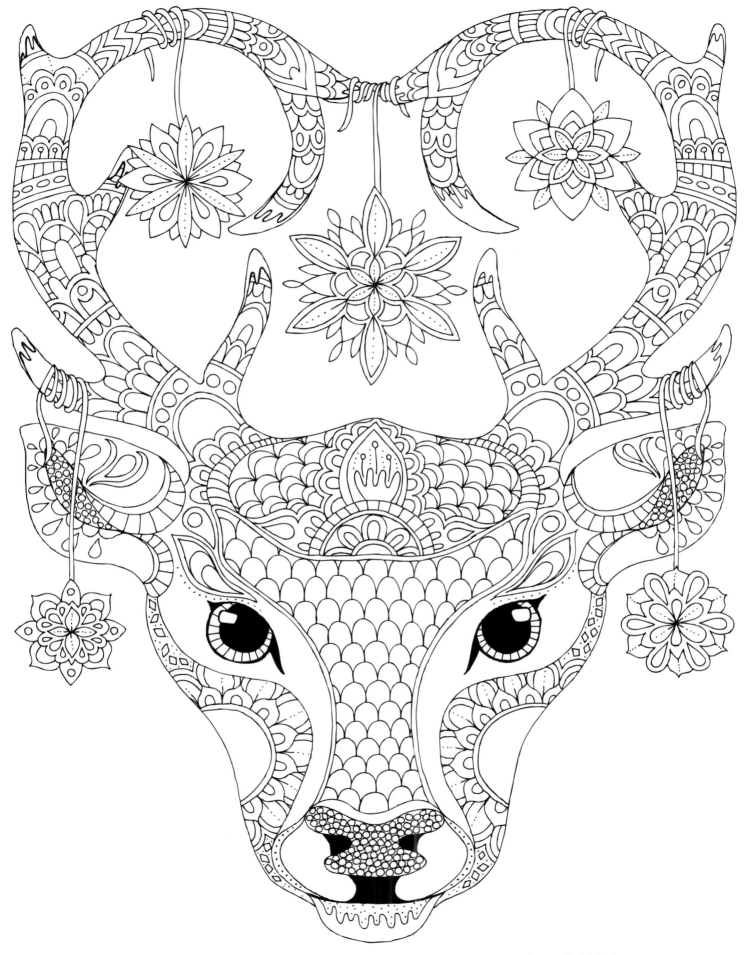

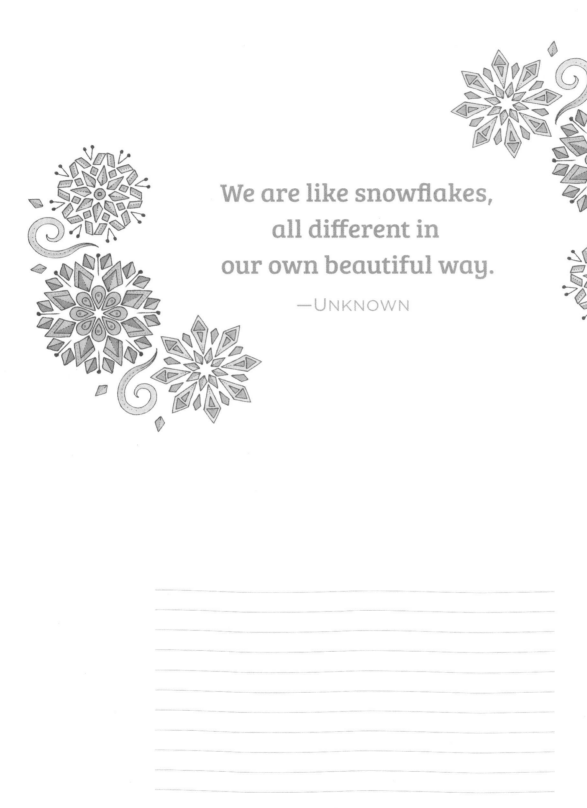

We are like snowflakes,
all different in
our own beautiful way.

—UNKNOWN

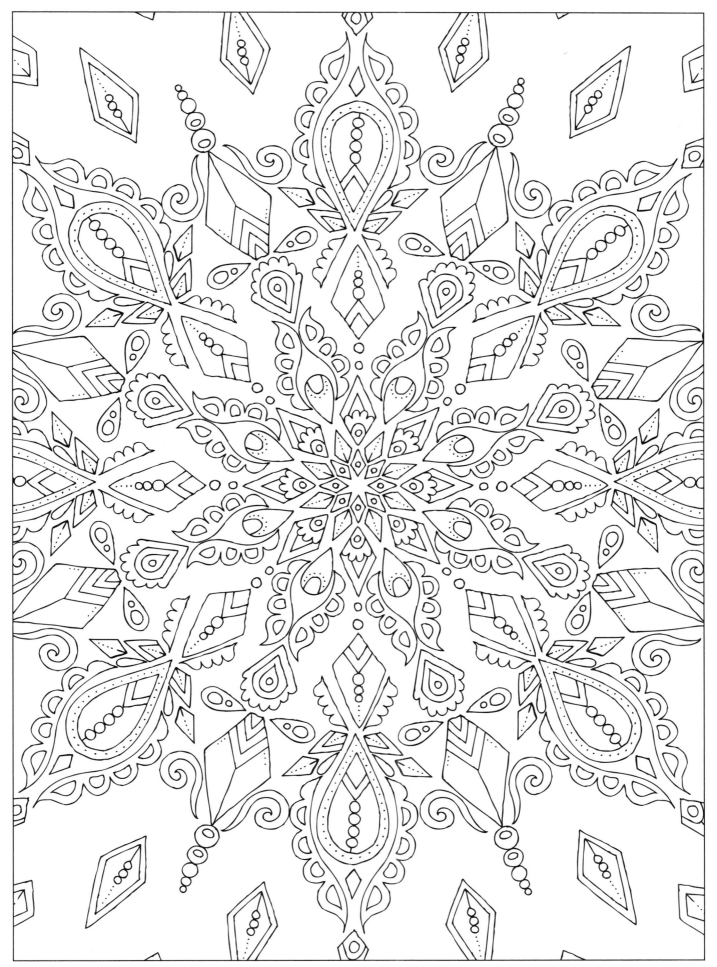

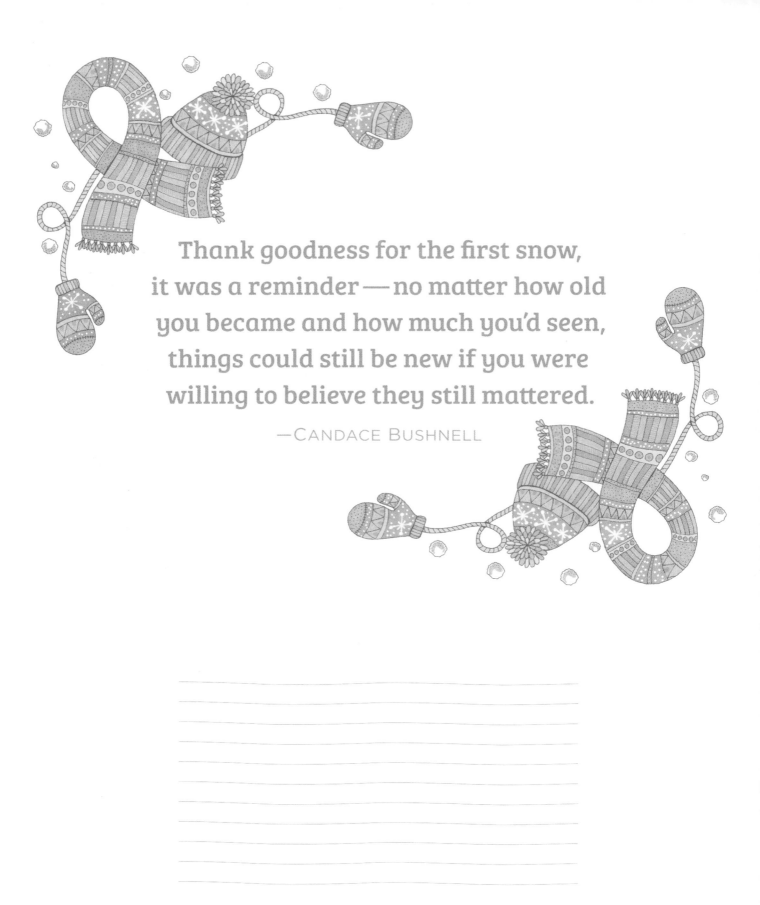

Thank goodness for the first snow,
it was a reminder—no matter how old
you became and how much you'd seen,
things could still be new if you were
willing to believe they still mattered.

—CANDACE BUSHNELL

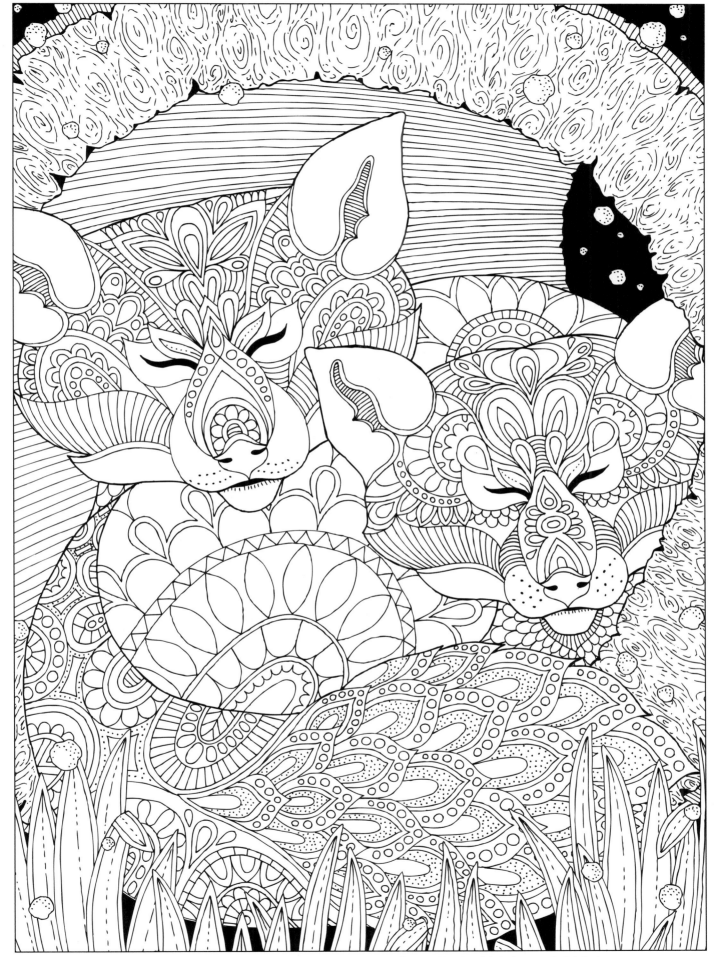

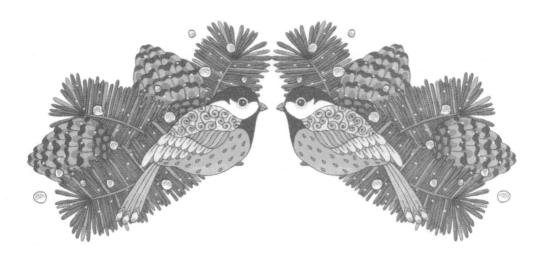

Some people are worth melting for.

—OLAF, *FROZEN*